Dream Doodles

A COLORING BOOK WITH A HIDDEN PICTURE TWIST

KATHY AHRENS

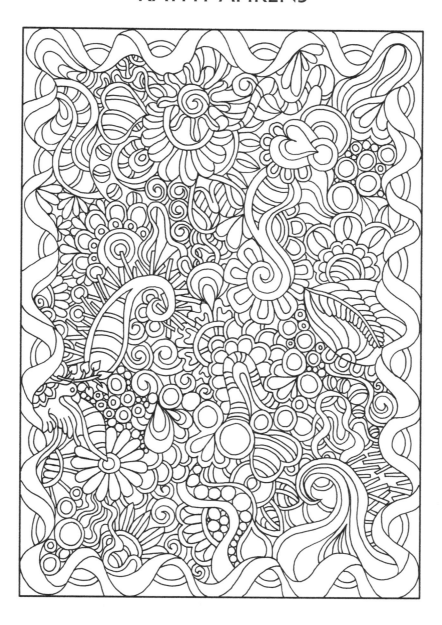

DOVER PUBLICATIONS, INC.
MINEOLA, NEW YORK

This coloring book features twenty-eight intricate images designed to offer a mind-expanding experience to the advanced colorist. But there's more here than meets the eye—look closely to find the bees, butterflies, tea cups, mushrooms, and other surprising figures hidden amid the wild, swirling designs. Answers are included, and the illustrations are printed on one side of a perforated page only for easy removal and display.

Copyright
Copyright © 2015 by Dover Publications, Inc.
All rights reserved.

Bibliographical Note
Dream Doodles Coloring Book: A Coloring Book with a Hidden Picture Twist
is a new work, first published by Dover Publications, Inc., in 2015.

International Standard Book Number
ISBN-13: 978-0-486-79902-5
ISBN-10: 0-486-79902-6

Manufactured in the United States by RR Donnelley
79902606 2015
www.doverpublications.com

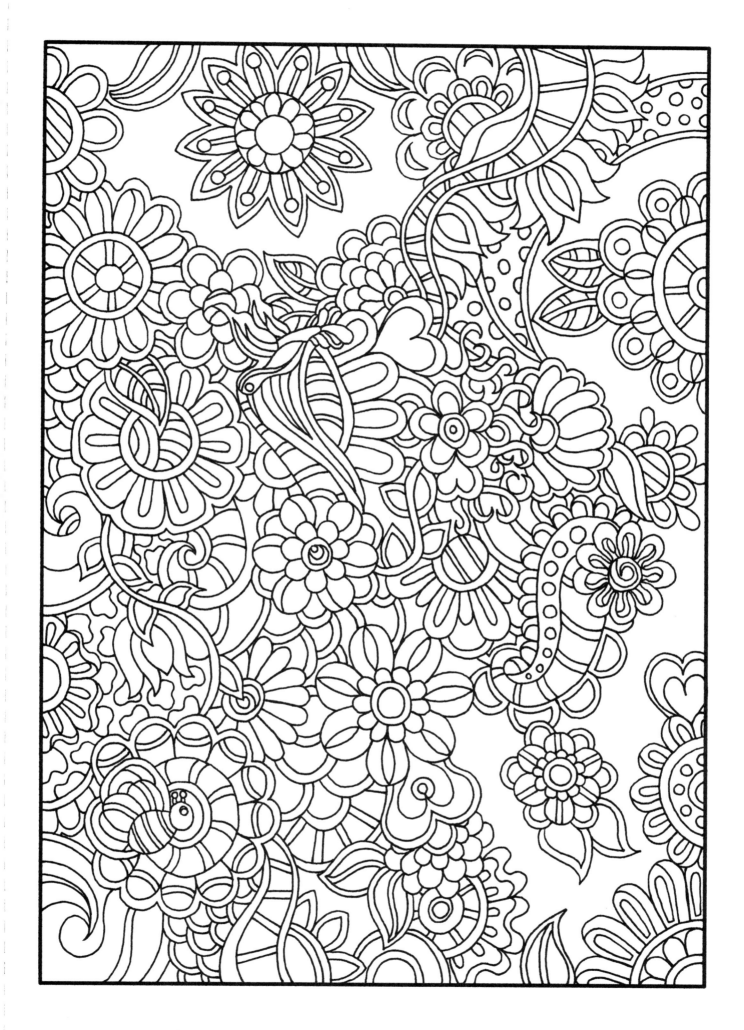

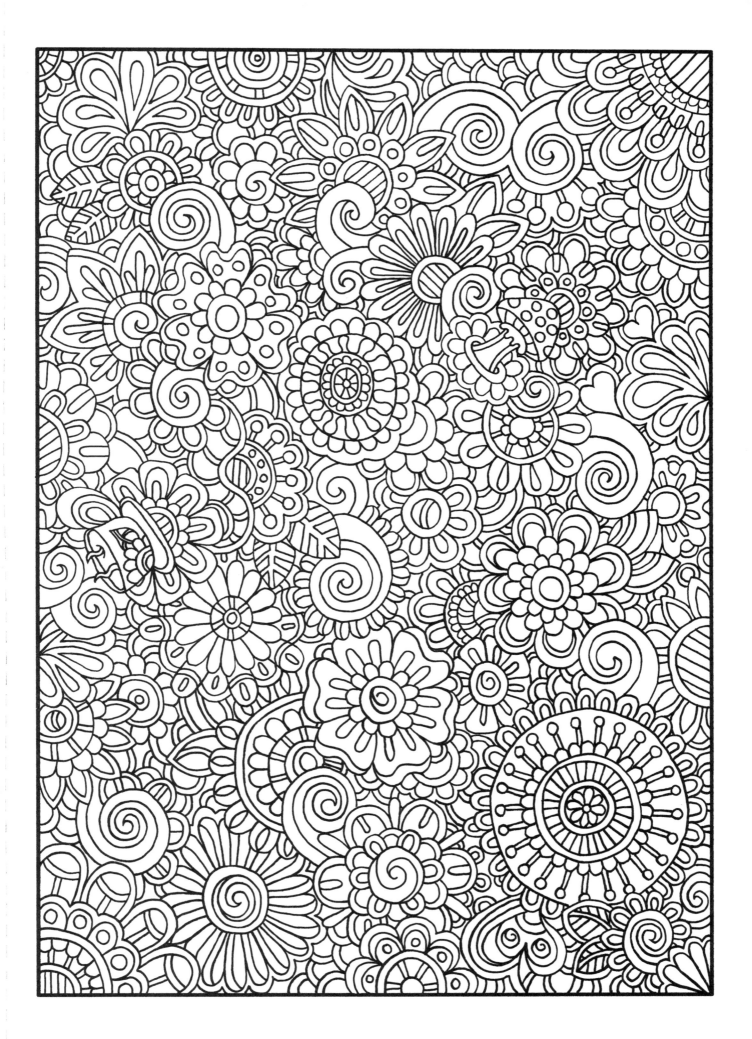

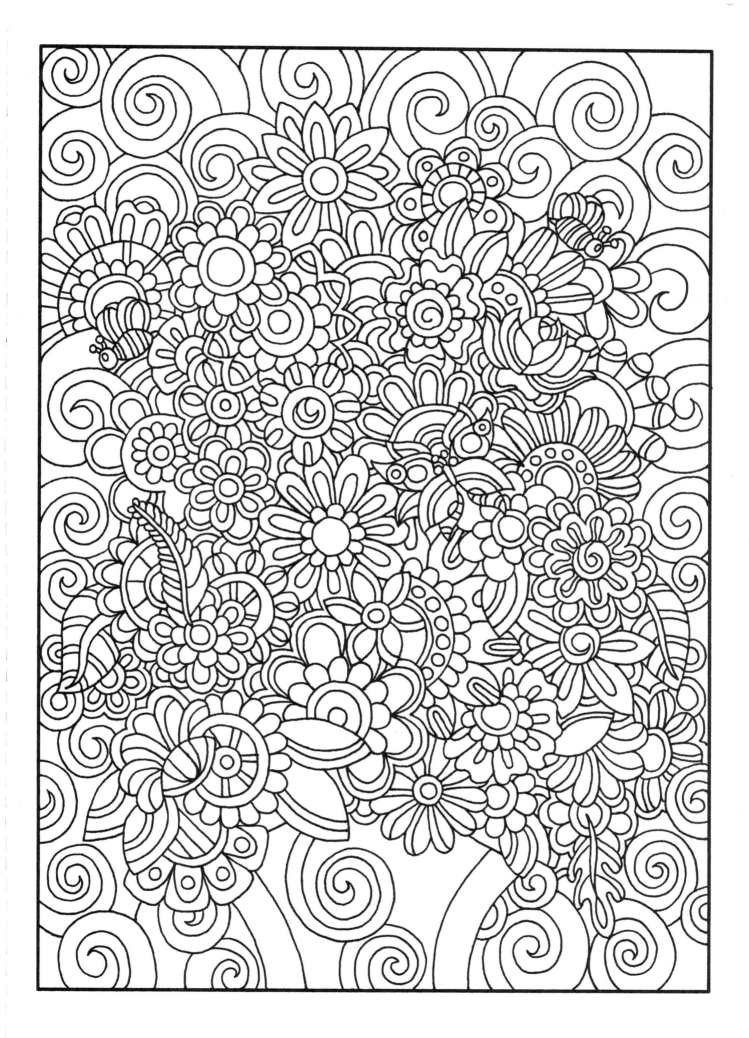

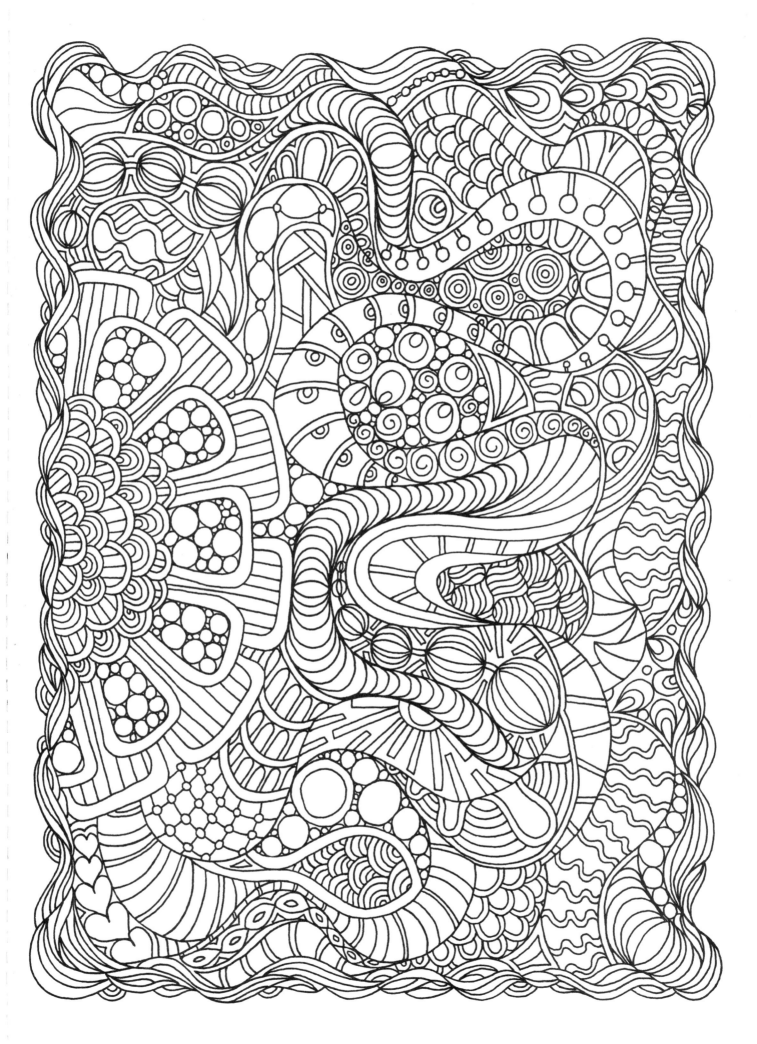

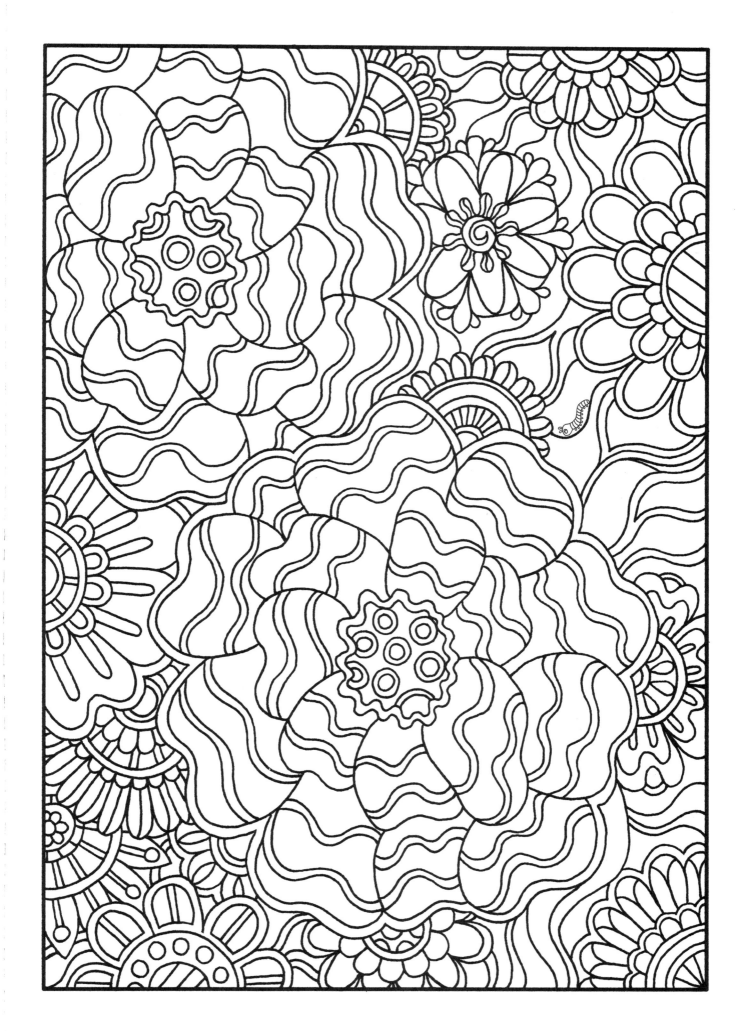

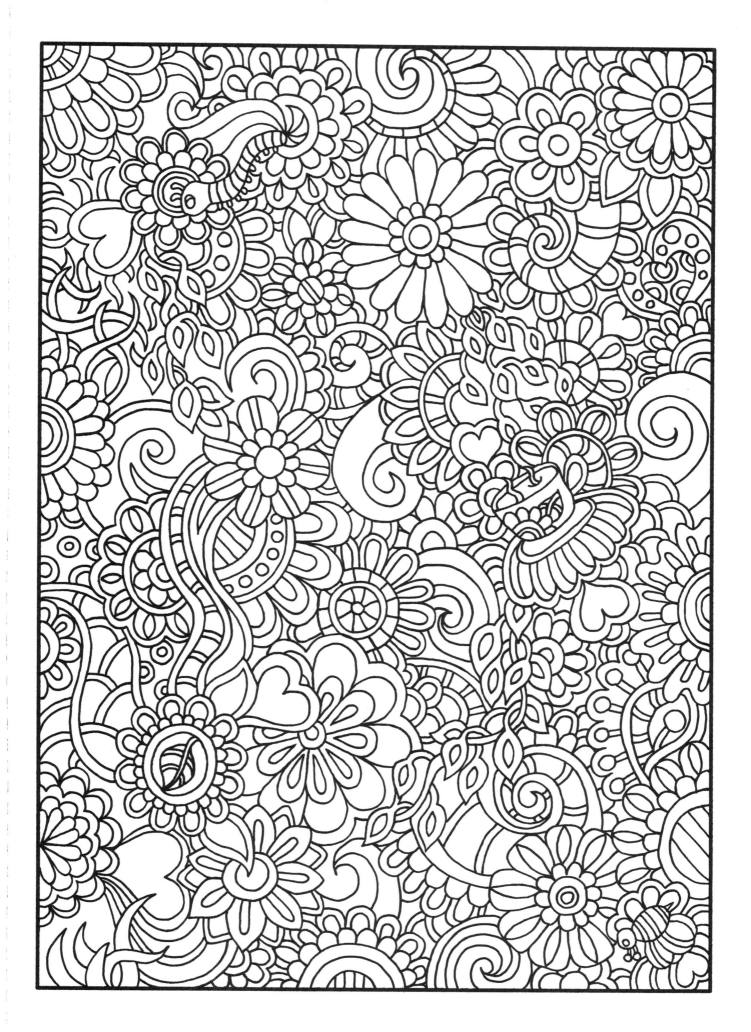

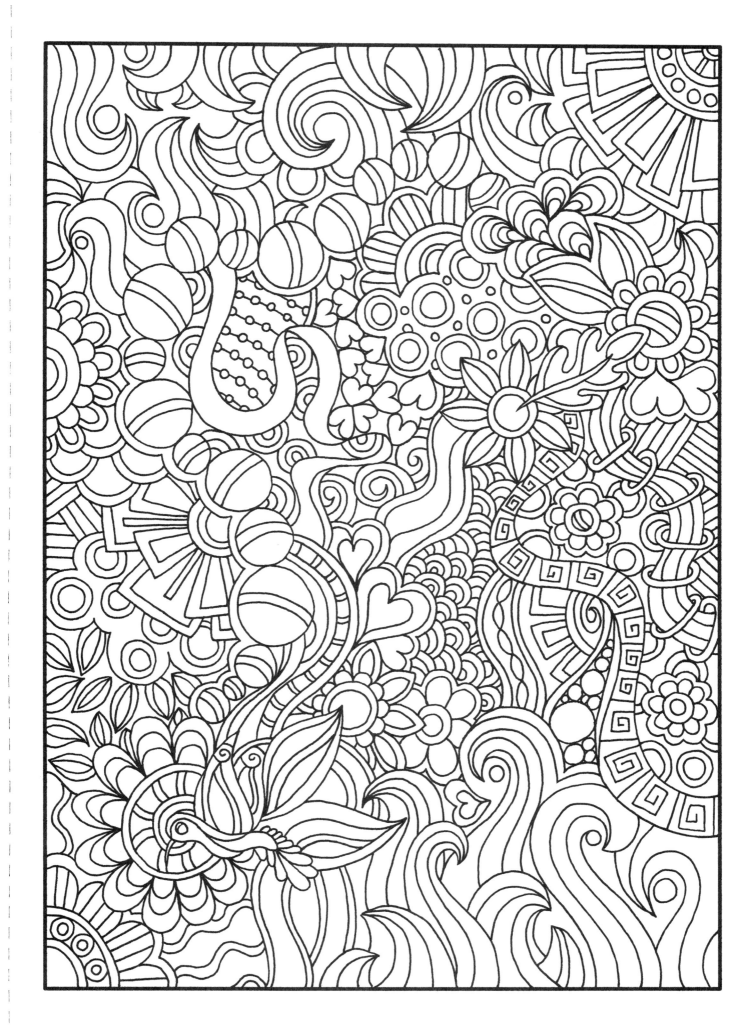

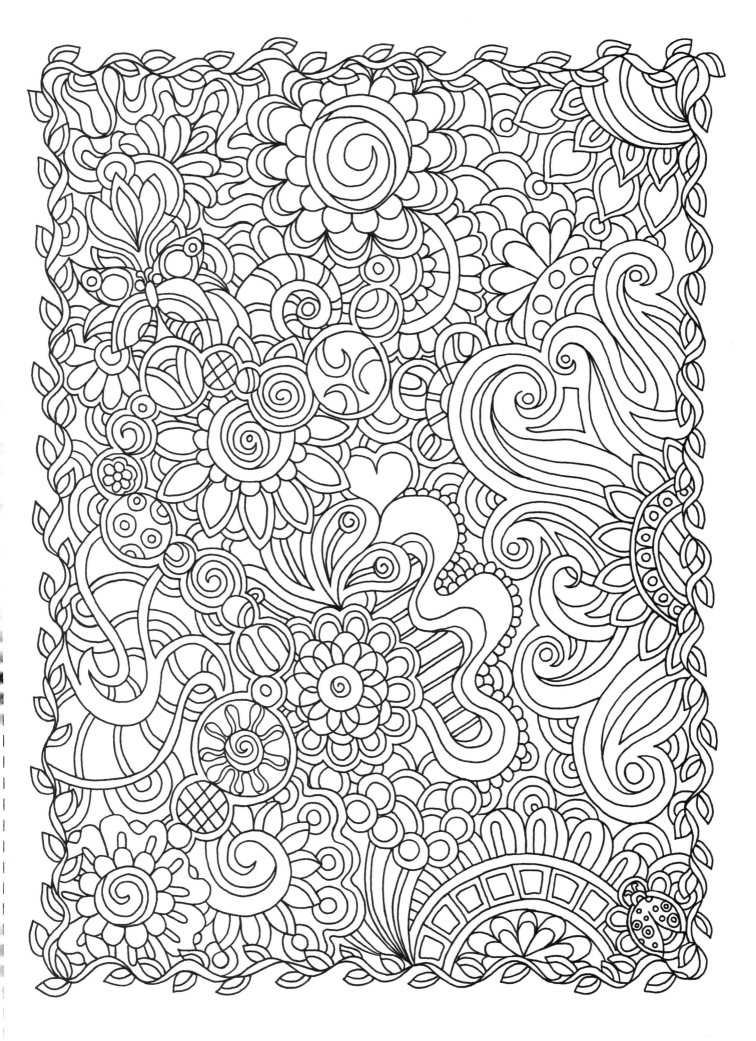

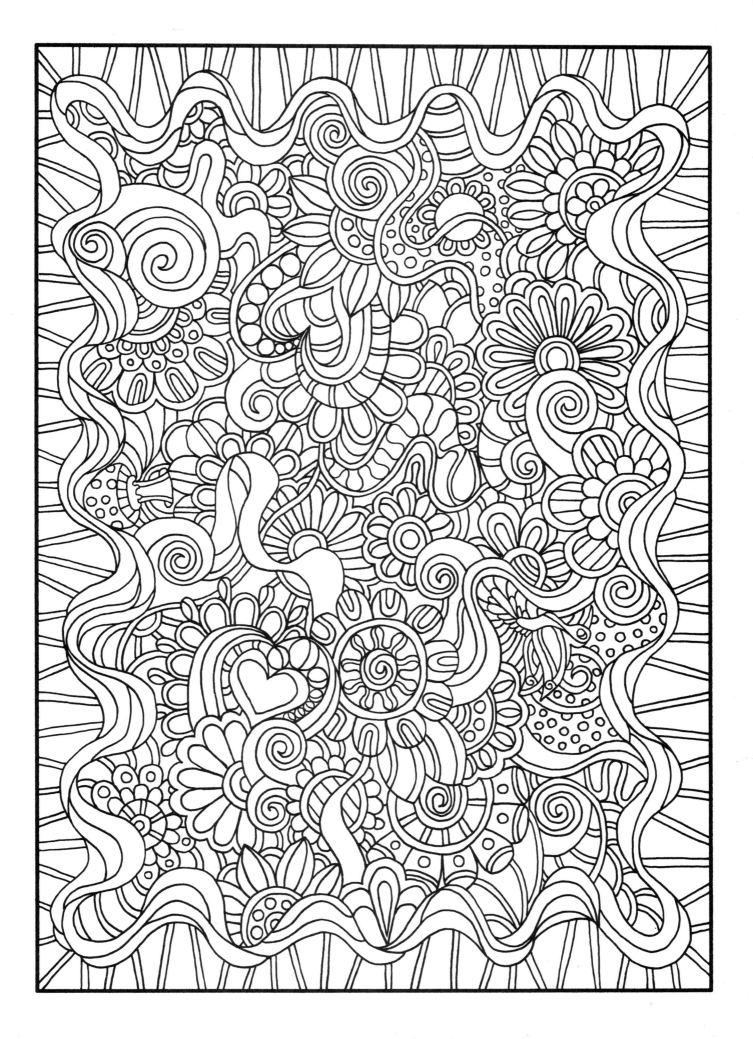

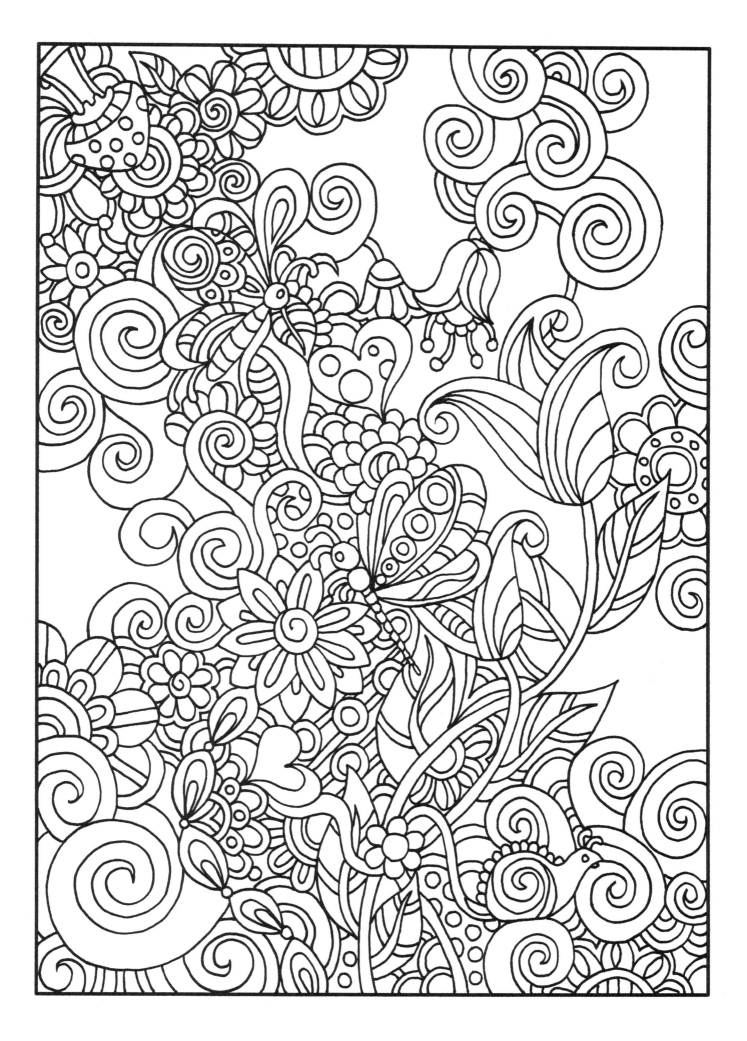

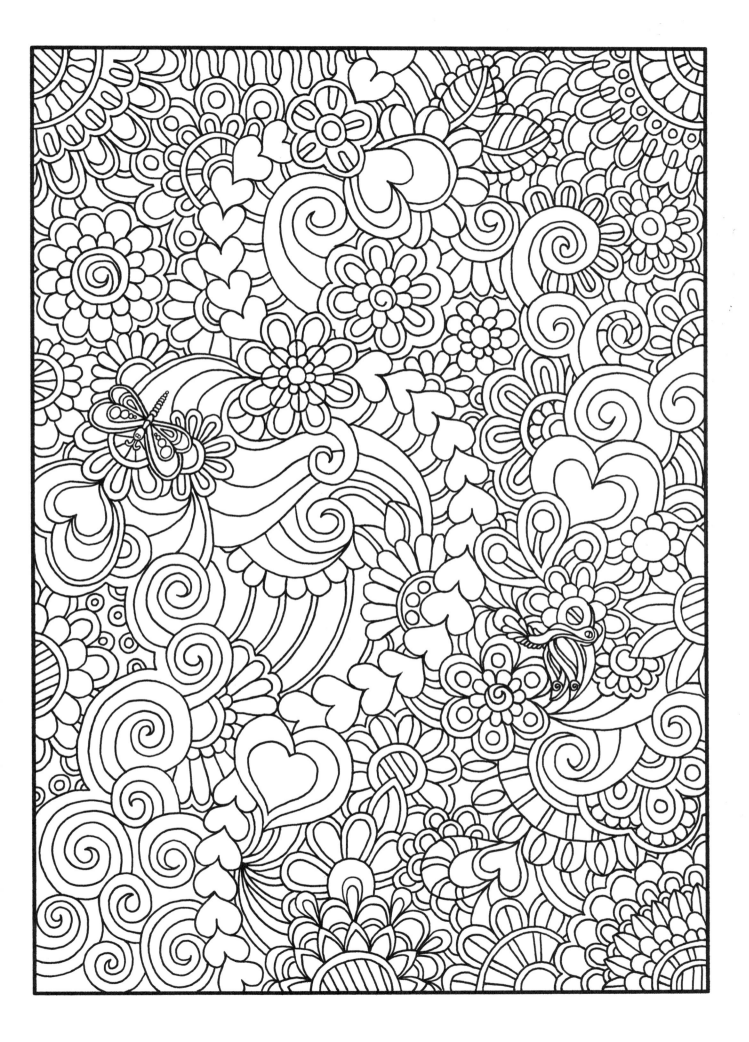

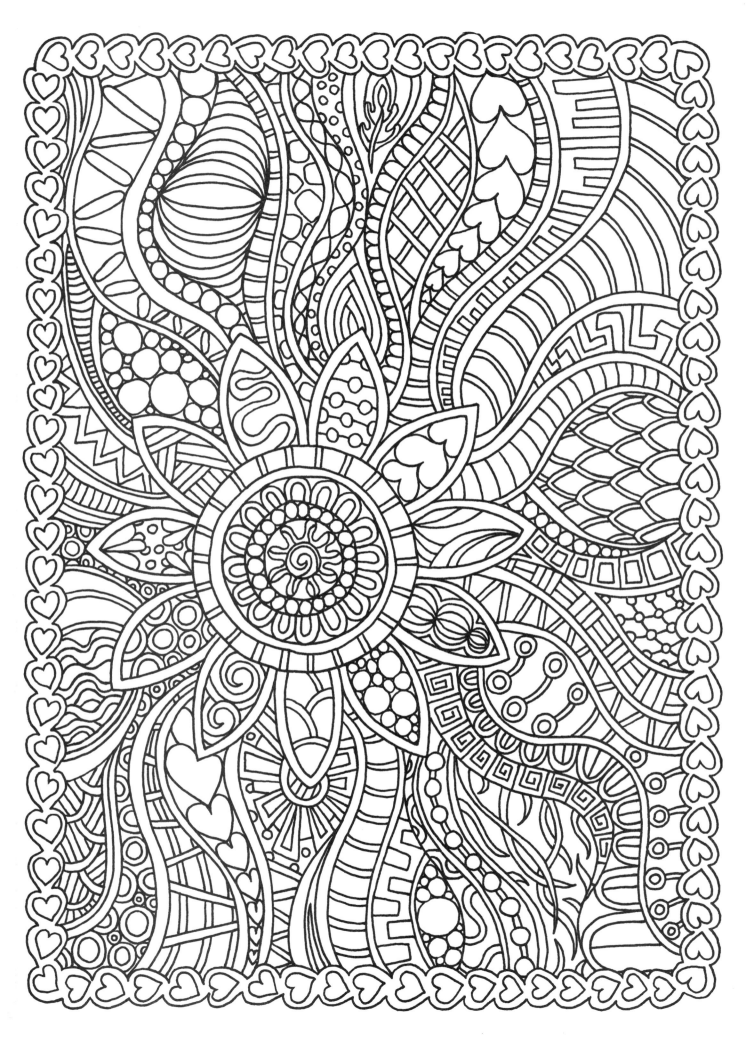

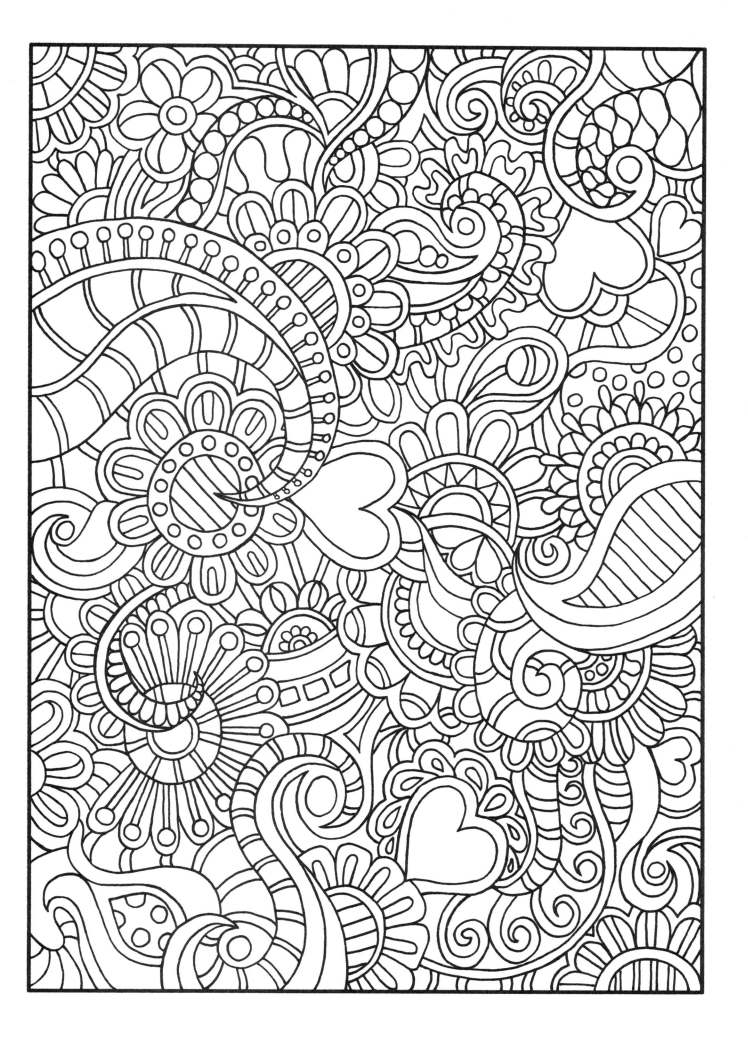

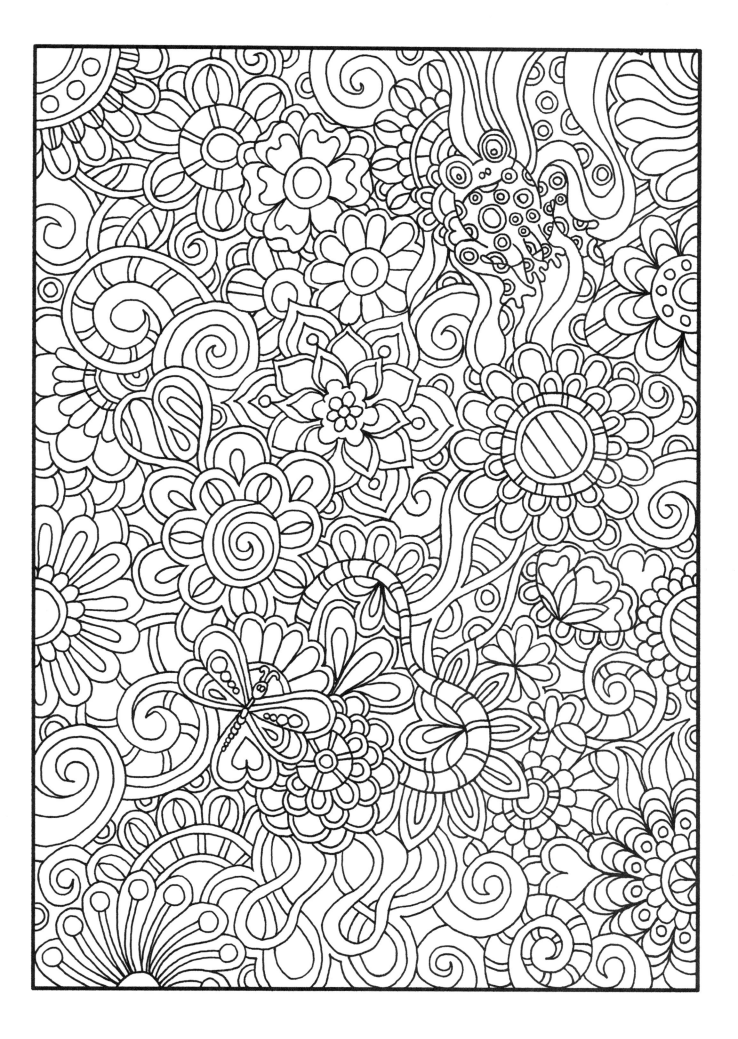

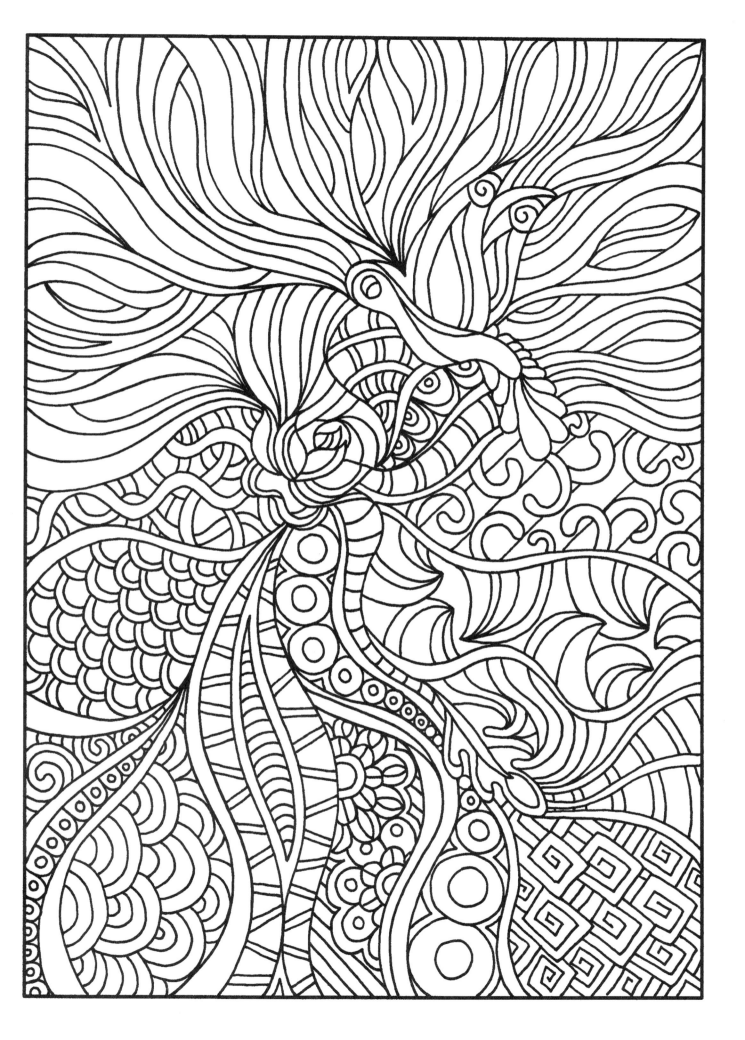

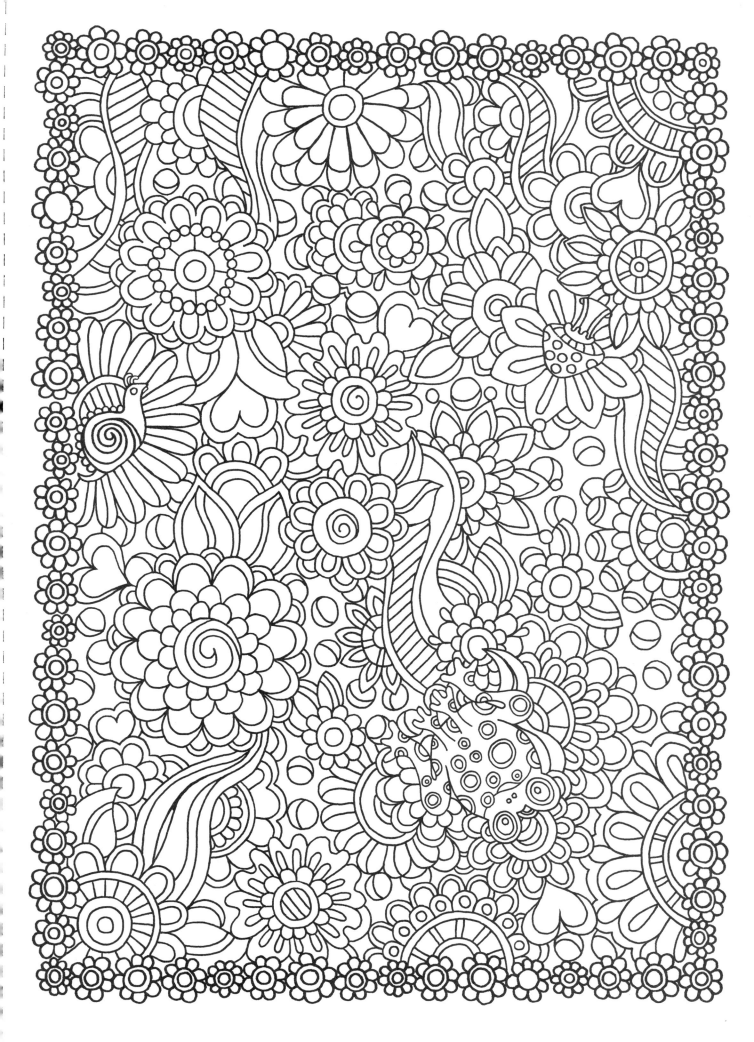

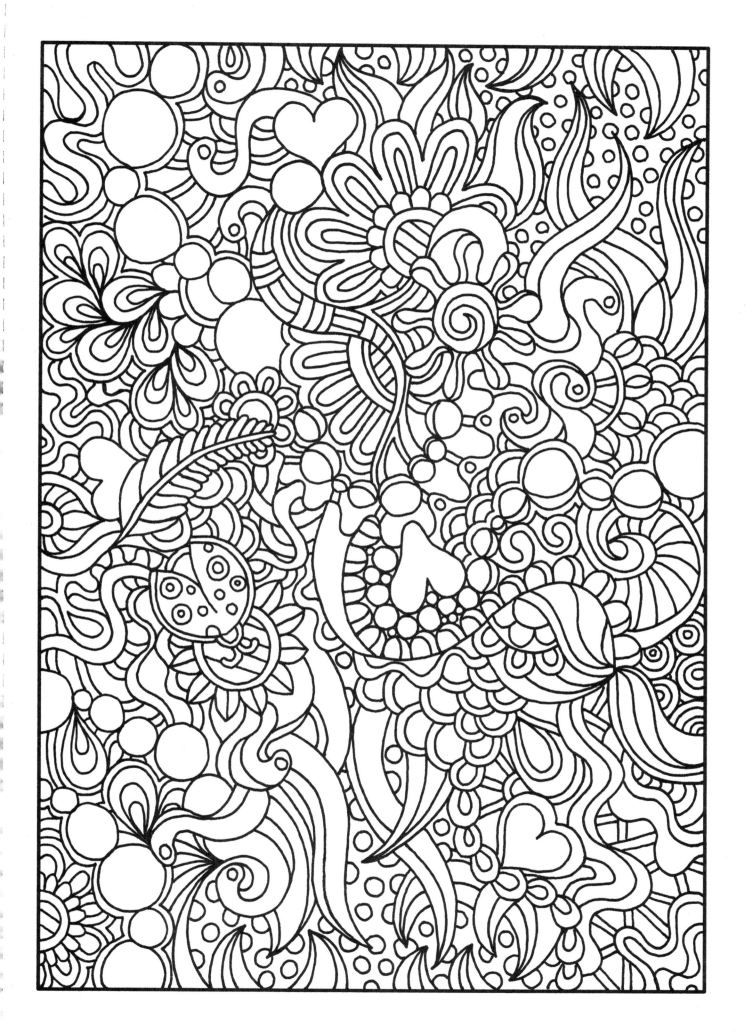

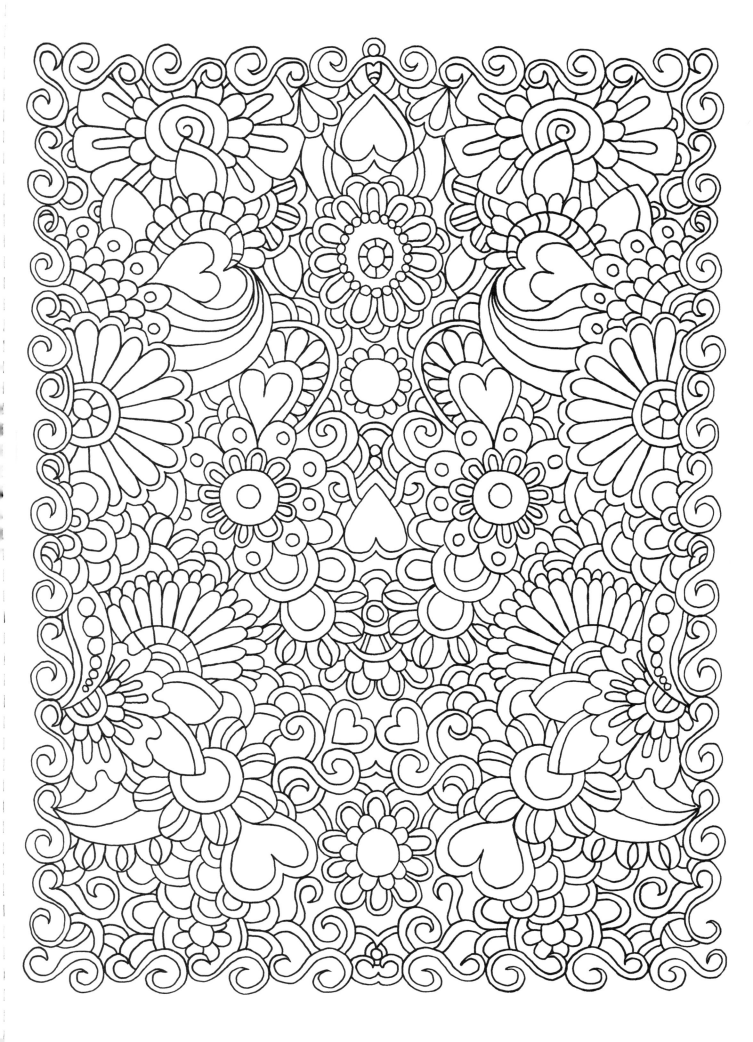

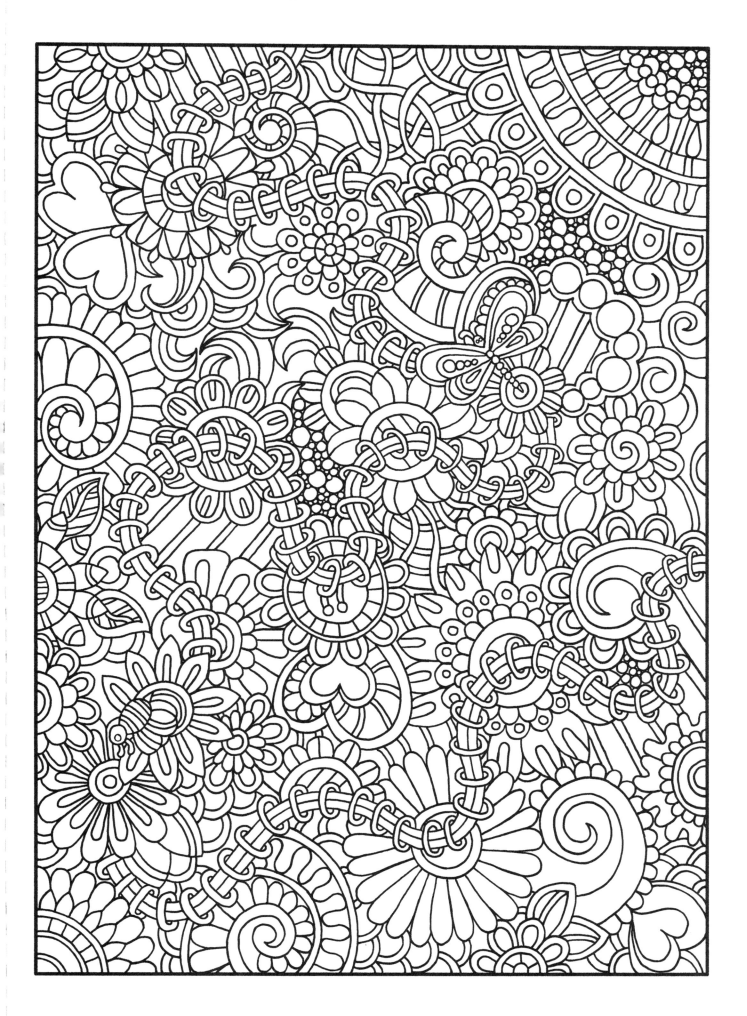

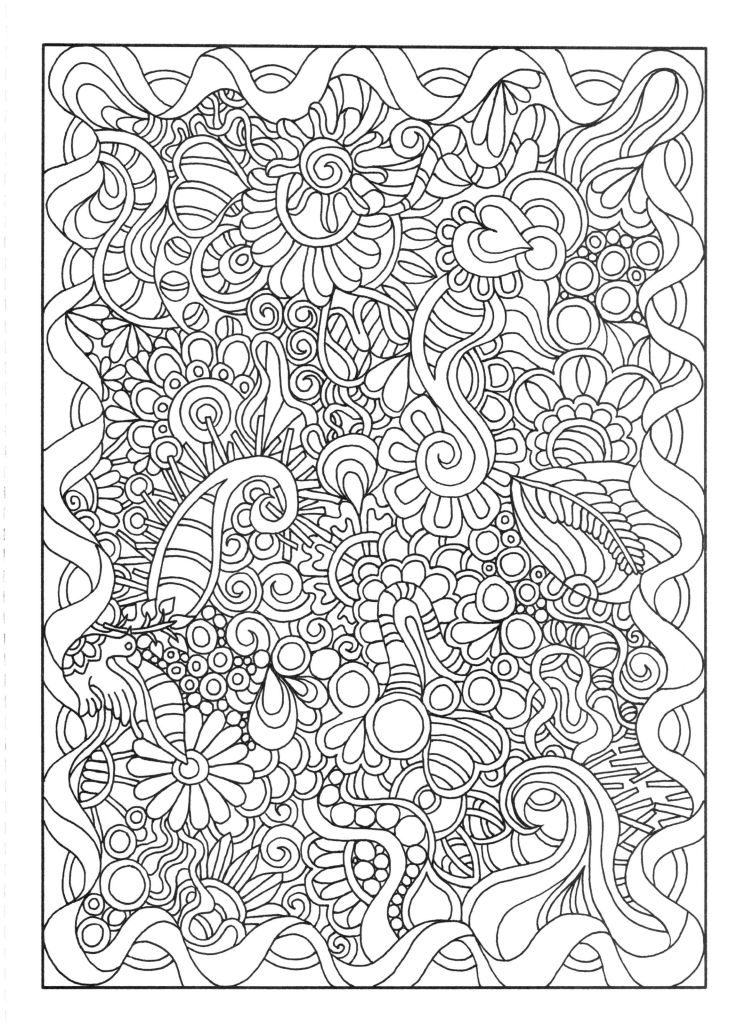

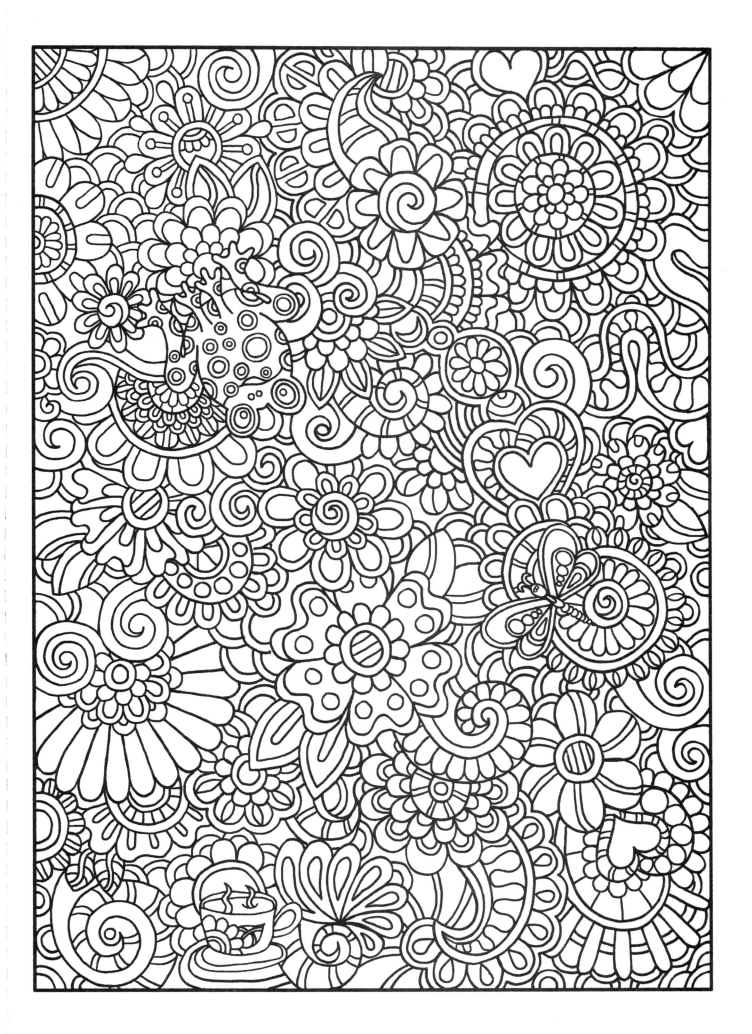

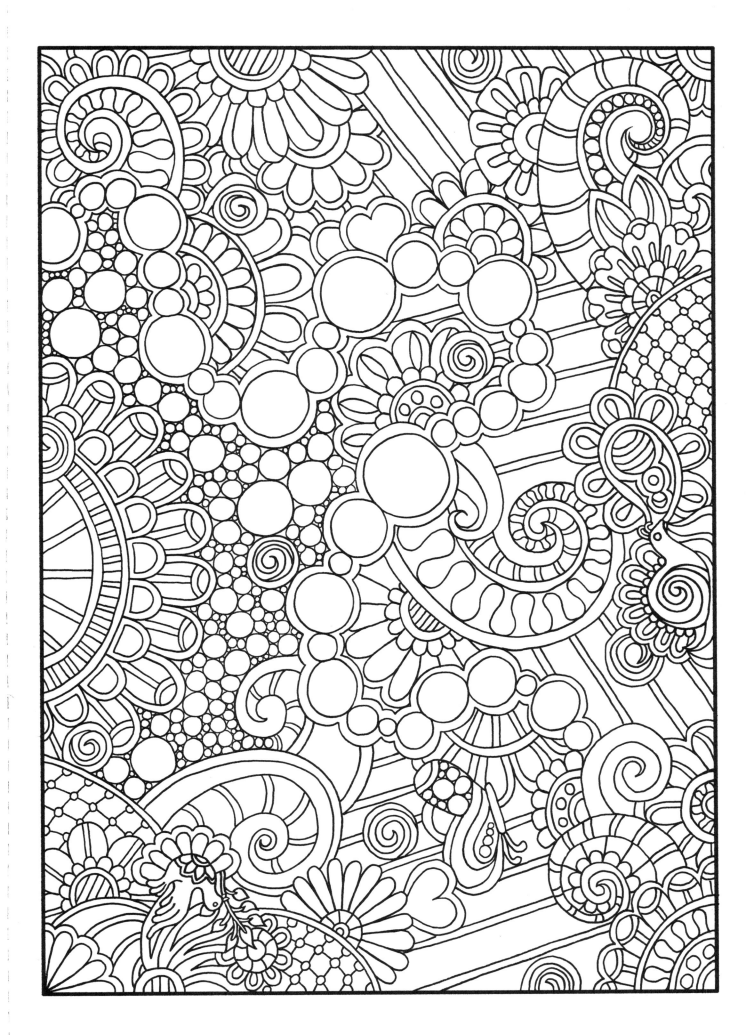

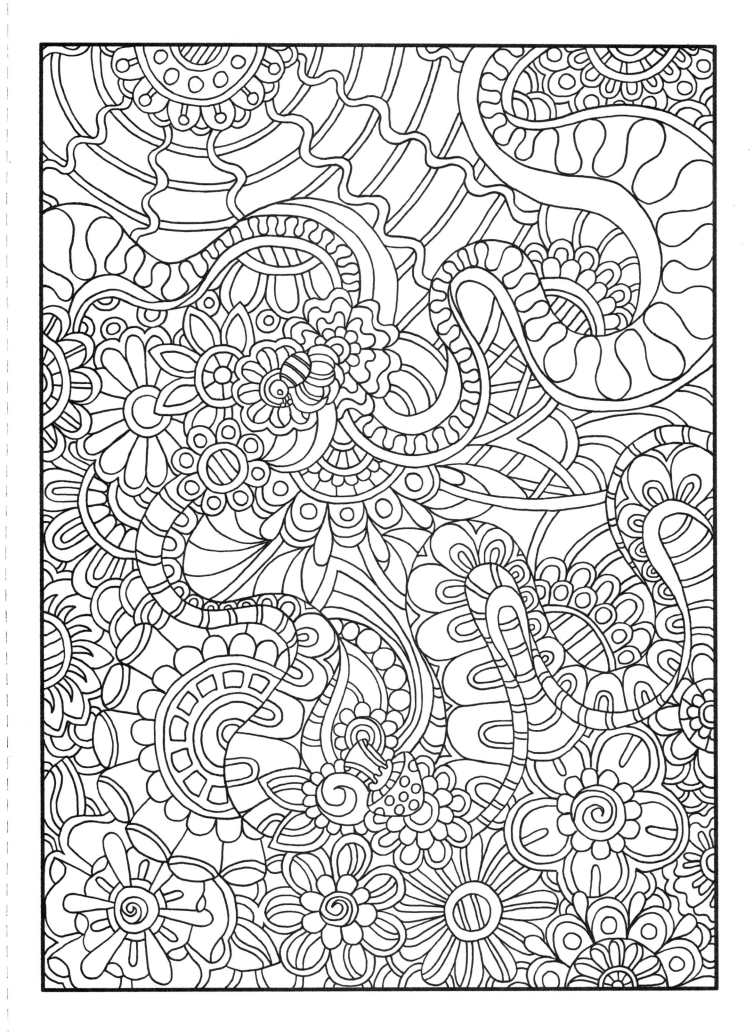

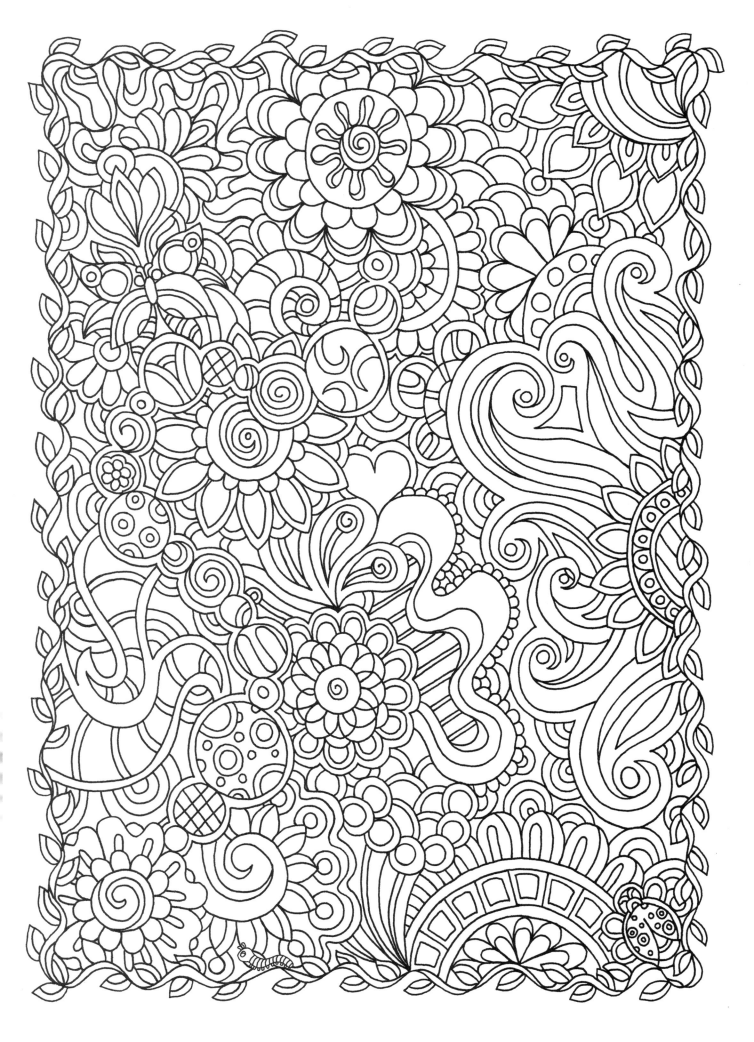

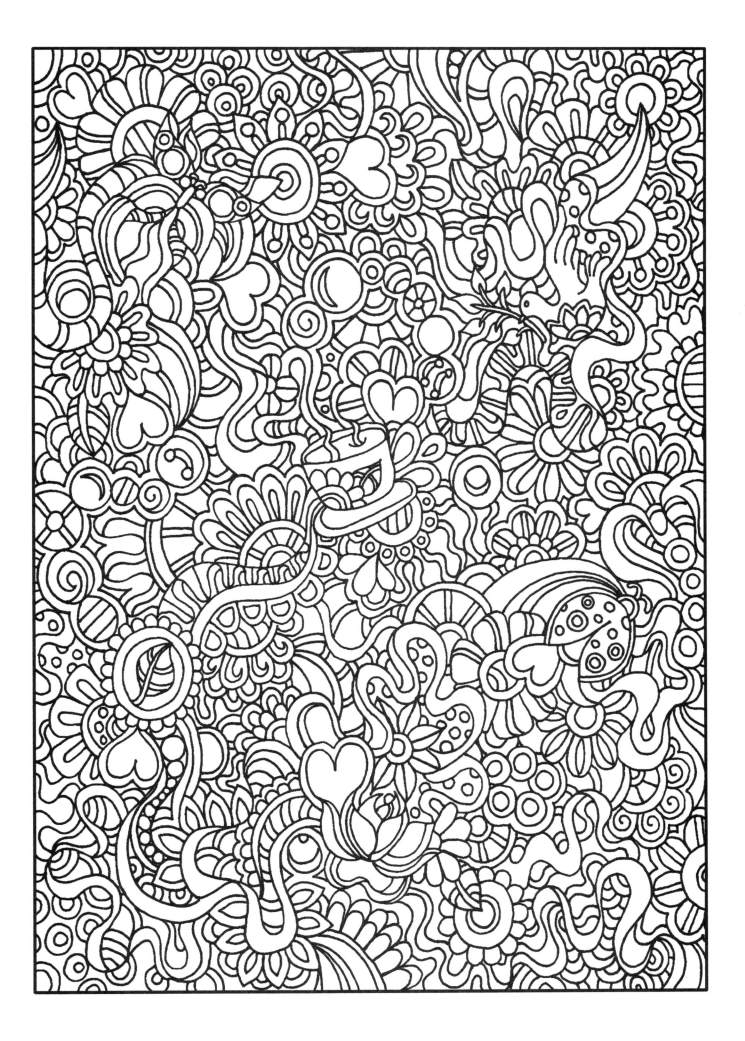

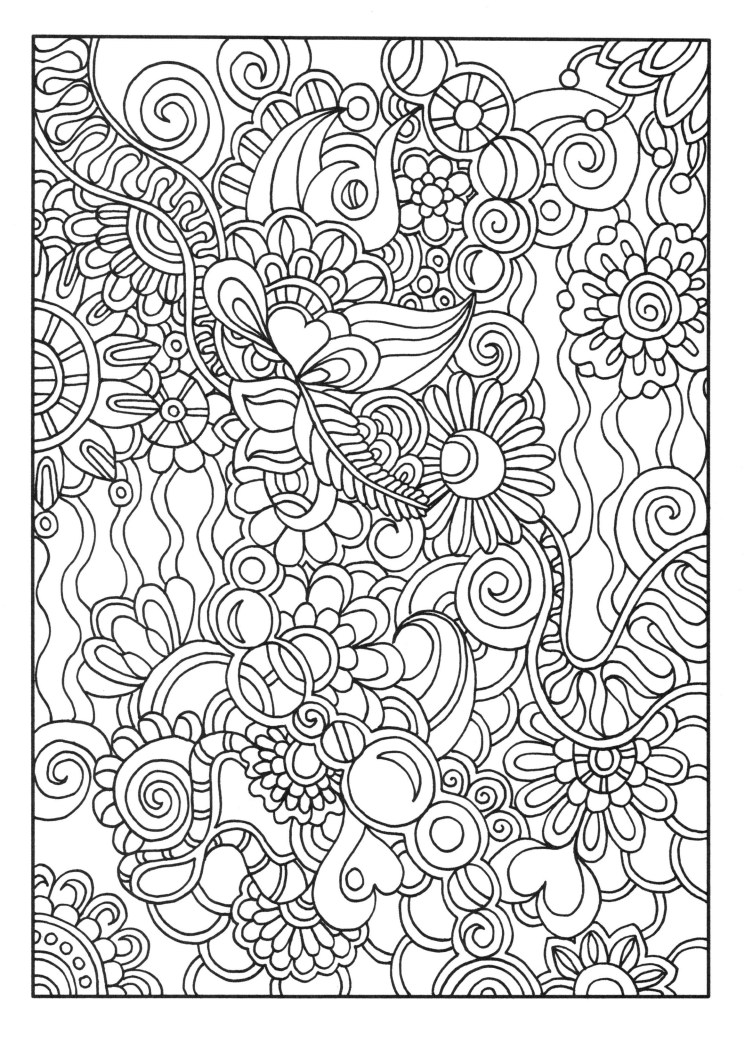

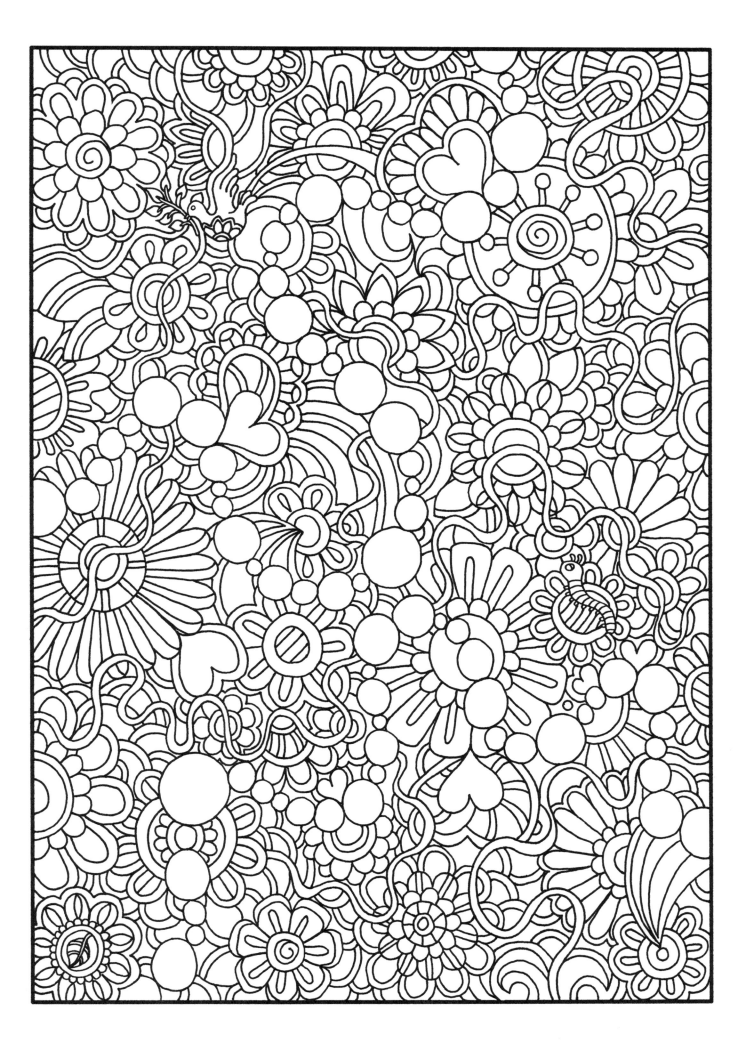

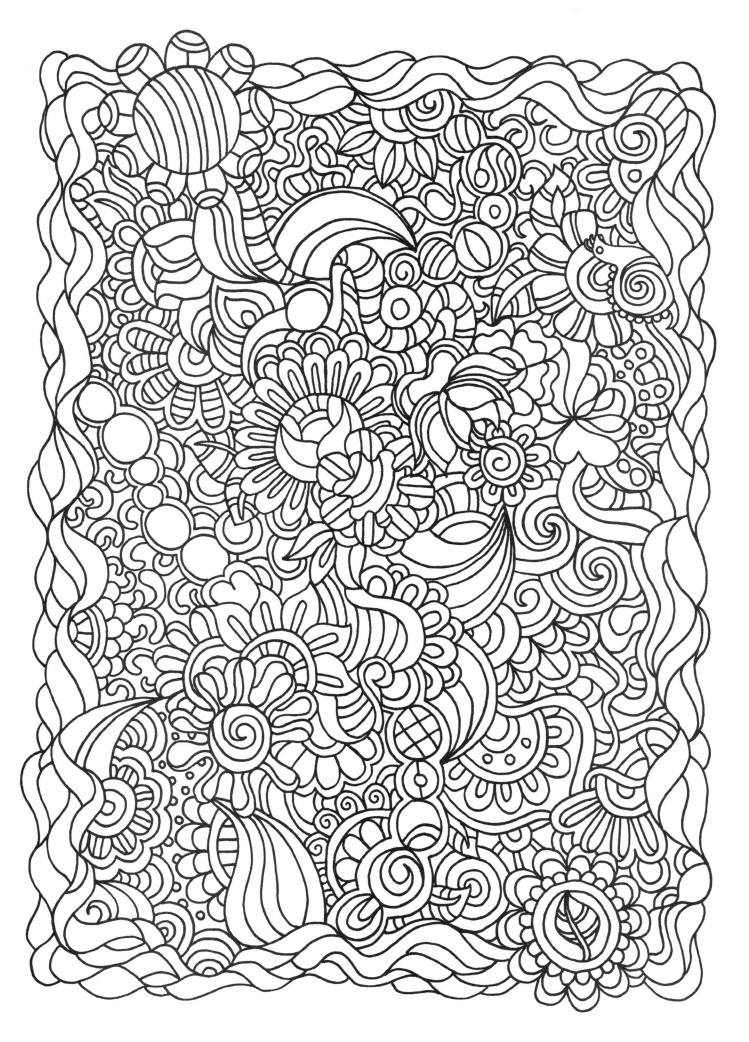

SOLUTIONS

page 1
Bee, Hummingbird, Sun

page 2
Mushroom, Tea Cup

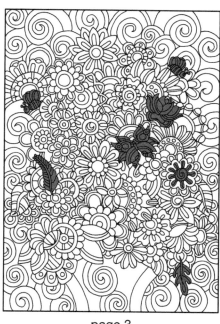

page 3
Bee (2), Lotus Flower, Butterfly,
Sun, Feather, Leaf

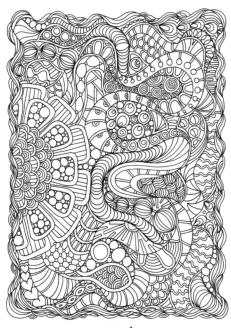

page 4

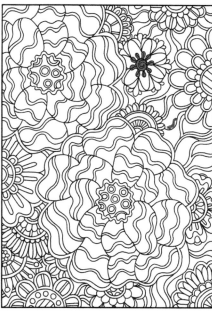

page 5
Sun, Caterpillar

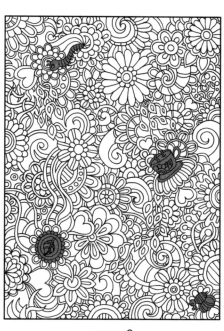

page 6
Caterpillar, Tea Cup,
Stepping Stone, Bee

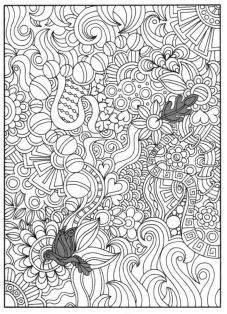

page 7
Leaf, Hummingbird

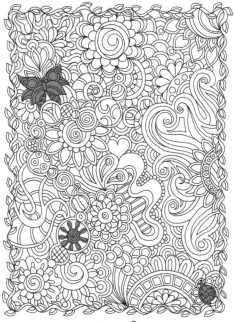

page 8
Butterfly, Sun, Lady Bug

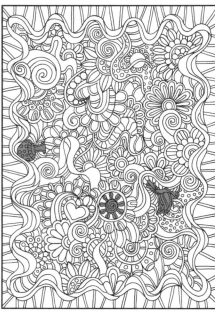

page 9
Mushroom, Sun, Hummingbird

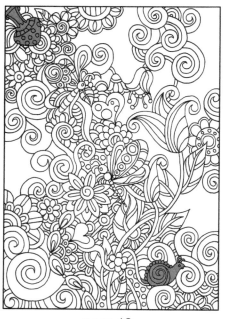

page 10
Mushroom, Snail

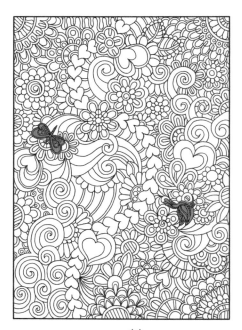

page 11
Dragonfly, Hummingbird

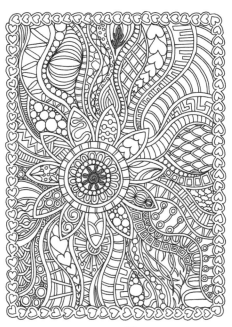

page 12
Leaf, Sun

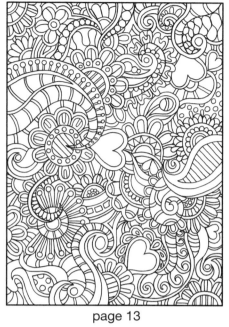

page 13

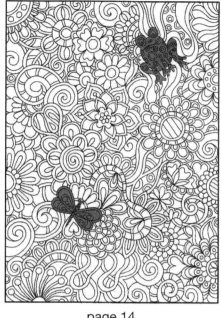

page 14
Frog, Dragonfly

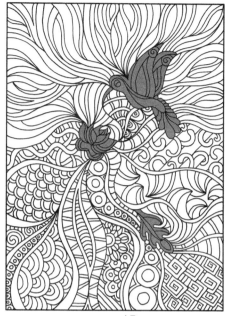

page 15
Hummingbird, Lotus Flower, Leaf

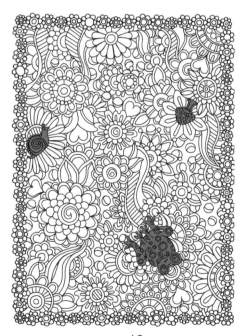

page 16
Snail, Mushroom, Frog

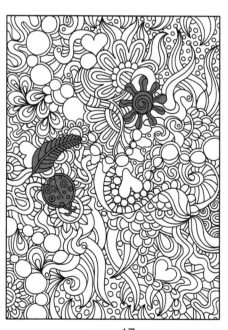

page 17
Sun, Feather, Lady Bug

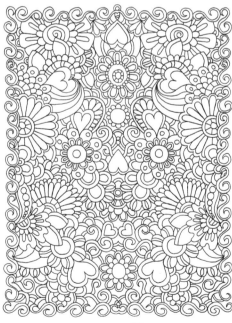

page 18

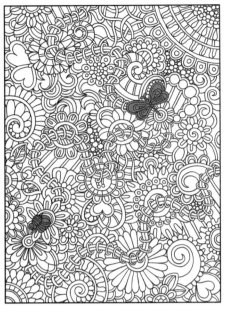

page 19
Dragonfly, Bee

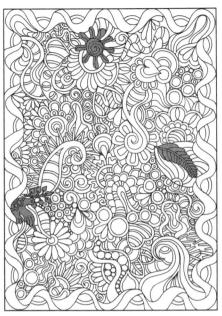

page 20
Sun, Feather, Dove

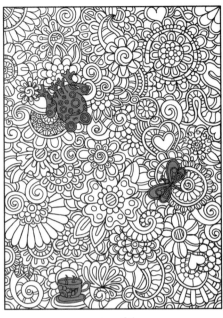

page 21
Frog, Dragonfly, Tea Cup

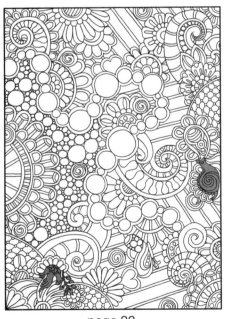

page 22
Snail, Dove

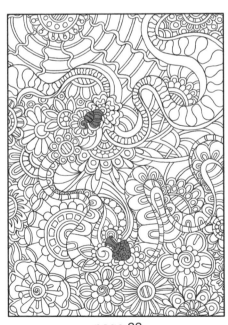

page 23
Bee, Mushroom

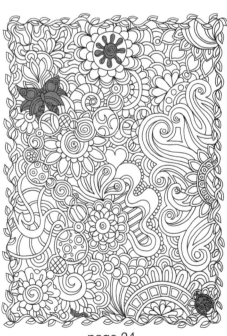

page 24
Butterfly, Sun, Lady Bug,
Caterpillar

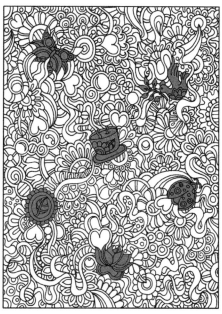

page 25
Butterfly, Dove, Tea Cup, Stepping
Stone, Lady Bug, Lotus Flower

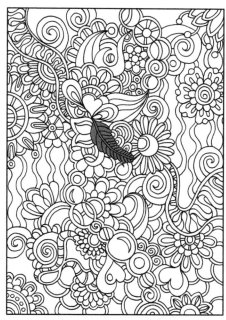

page 26
Feather

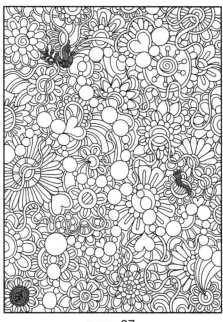

page 27
Dove, Caterpillar, Stepping Stone

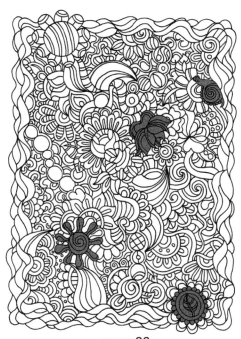

page 28
Lotus Flower, Snail, Sun,
Stepping Stone